Coloring Nature
to calm yourself

Text by Peter Alden, Sarah Anne Hughes,
and Robert Michael Pyle
Illustrations by Sarah Anne Hughes,
Virginia Savage, and John Sill

Houghton Mifflin Harcourt
Boston New York

Previously published material first appeared in the following works:
Peterson Field Guide® Coloring Books: Birds by Peter Alden and John Sill, copyright © 1982 by Houghton Mifflin Harcourt Publishing Company; *Peterson Field Guide® Coloring Books: Butterflies* by Robert Michael Pyle and Sarah Anne Hughes, copyright © 1993 by Houghton Mifflin Harcourt Publishing Company; *Peterson Field Guide® Coloring Books: Wildflowers* by Virginia Savage, copyright © 1982 by Houghton Mifflin Harcourt Publishing Company.

Morning glory illustration on page 13 by Gail Piazza, copyright © Houghton Mifflin Harcourt Publishing Company.

Background designs on pages 19, 63, and 87 are reproduced from *Geometric Patterns.* Copyright © 1999 Pepin van Roojen. All rights reserved.

Background designs on pages 27, 41, 49, 77, and 83 are reproduced from *Pattern Sourcebook: Japanese Style 2.* Copyright © 2006 Shigeki Nakamura and copyright © 2009 Rockport Publishers, Inc. All rights reserved.

Book design by Kat and James Black

For information about permission to reproduce selections from this book, write to: trade.permissions@hmhco.com or to:
Permissions, Houghton Mifflin Harcourt Publishing Company, 3 Park Avenue, 19th Floor, New York, New York 10016

www.hmhco.com

Library of Congress Cataloging-in-Publication Data
ISBN-13: 978-0-544-94440-4

Printed in China
SCP 10 9 8 7 6 5 4 3 2 1

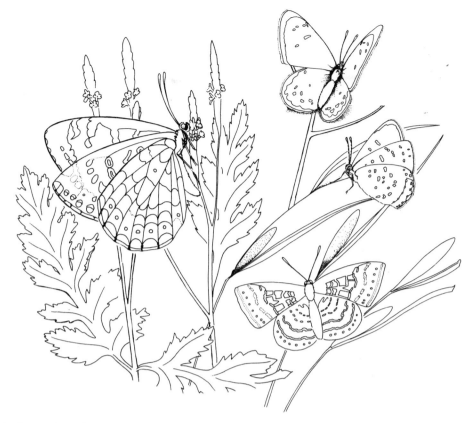

Flaubert said, "I believe that if one always looked at the skies, one would end up with wings." This sentiment speaks to the power of nature as a healer, an inspiration, a comfort, an escape, a motivator, and above all a reminder to take a moment and cherish the natural beauty that surrounds us. This coloring book is a celebration of nature—each page is filled with illustrations that are true replicas of what we find in the world around us. The illustrations were meticulously drawn by naturalists to represent actual birds, butterflies, and flowers. Notice the shapes and patterns of the wings, tails, petals, and leaves, and you may even find yourself recalling the early-morning sound of birds busily chirping or the pleasing fragrance of a particular wildflower.

You might even learn a thing or two from the fascinating facts sprinkled throughout!

These landscapes will stay with you long after you have completed your coloring adventure. One spread will blend into the next as you create a world of your own and escape into it for seconds or minutes or hours. You can start and stop where you want and close the book with the comfort of knowing all the joys that lie within and ahead. Whether it be a few moments to take your mind off the stresses of everyday life or the desire to spend the entire day immersed in the wonders of nature, this creation is all yours. Share it. Or don't. Just know you will return from the journey refreshed and invigorated, with a sense of calm that will remain long after you finish coloring.

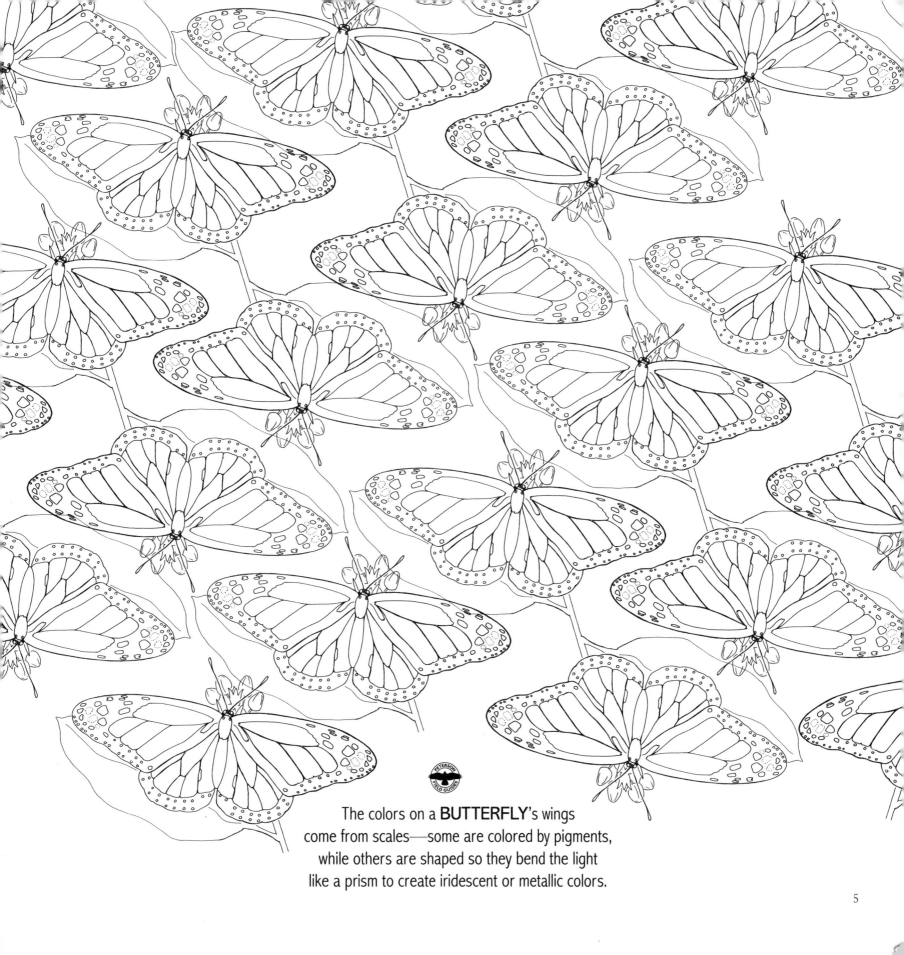

The colors on a **BUTTERFLY**'s wings
come from scales—some are colored by pigments,
while others are shaped so they bend the light
like a prism to create iridescent or metallic colors.

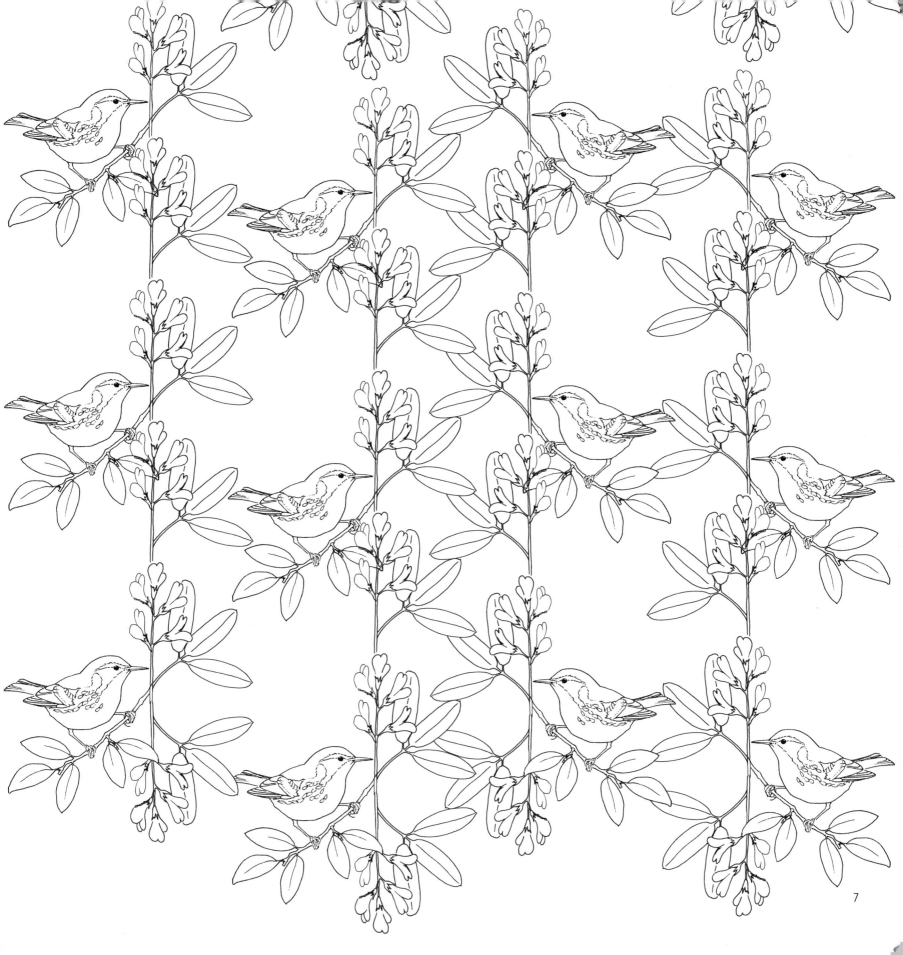

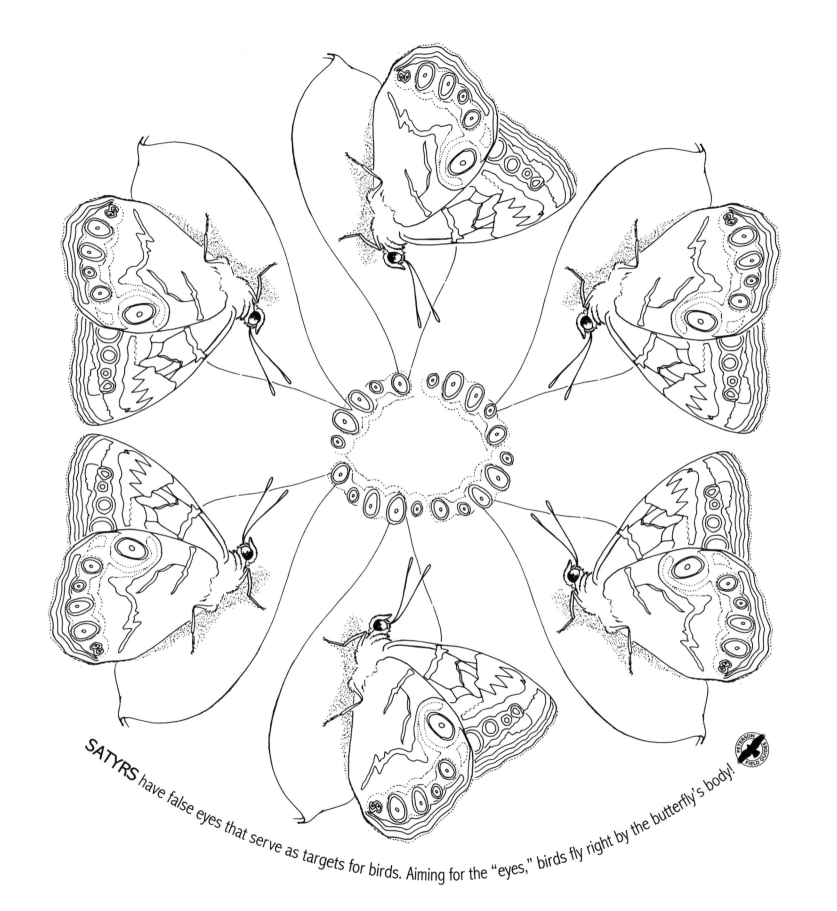

SATYRS have false eyes that serve as targets for birds. Aiming for the "eyes," birds fly right by the butterfly's body!

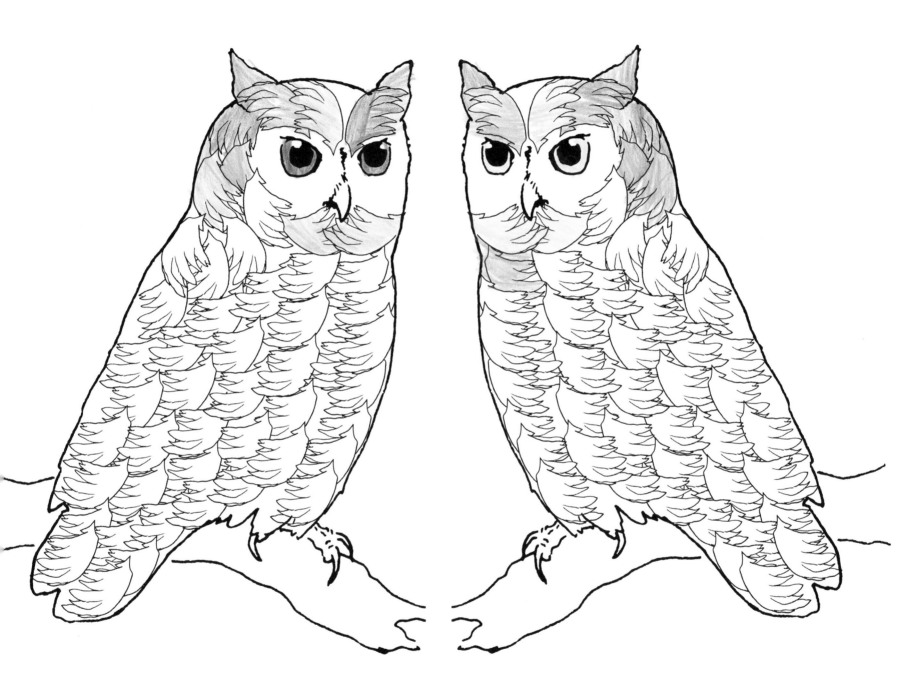

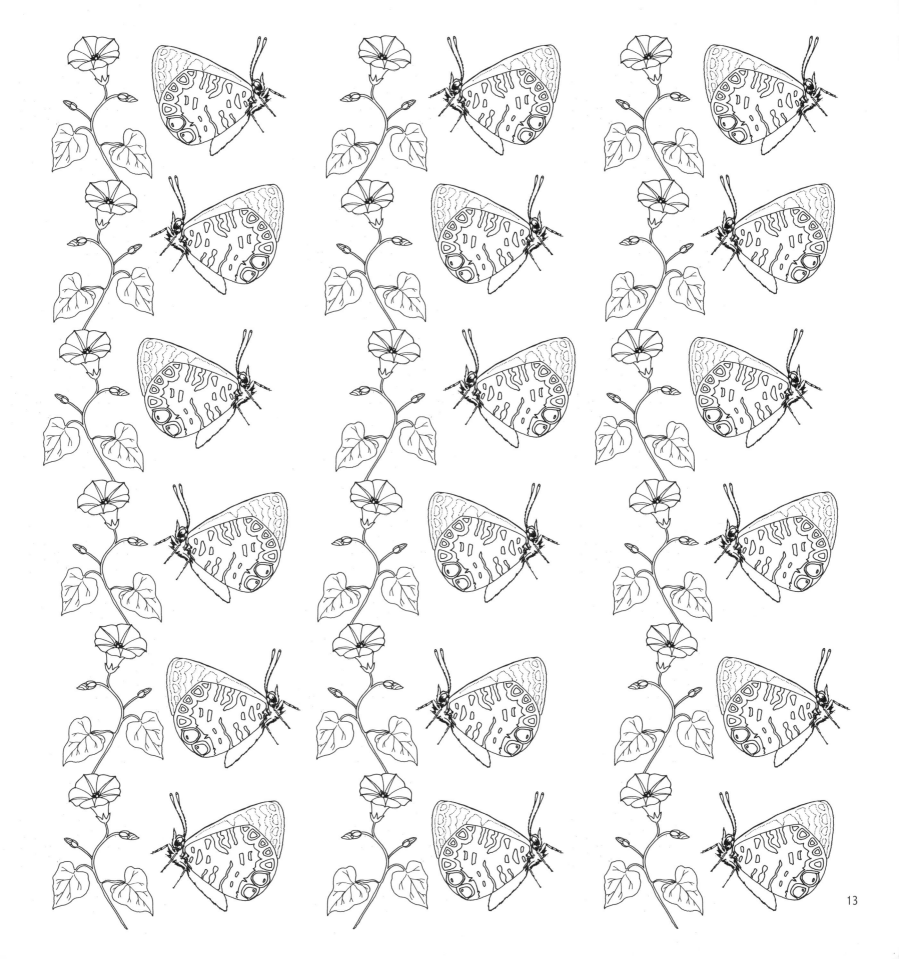

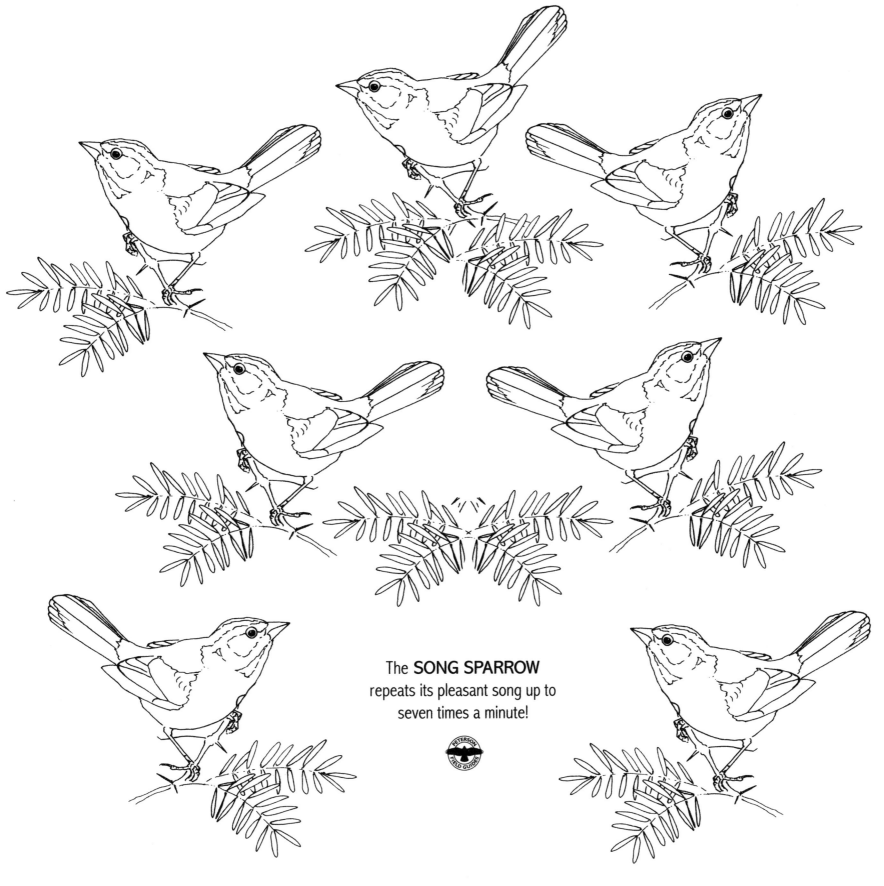

The **SONG SPARROW**
repeats its pleasant song up to
seven times a minute!

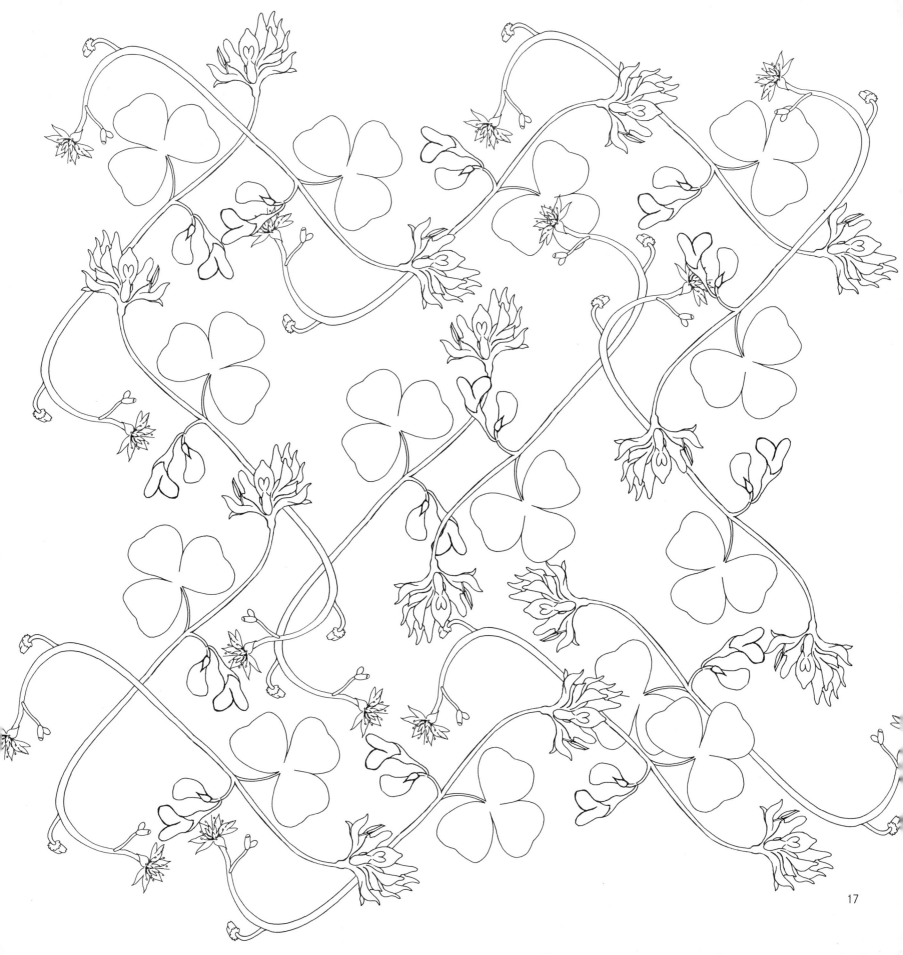

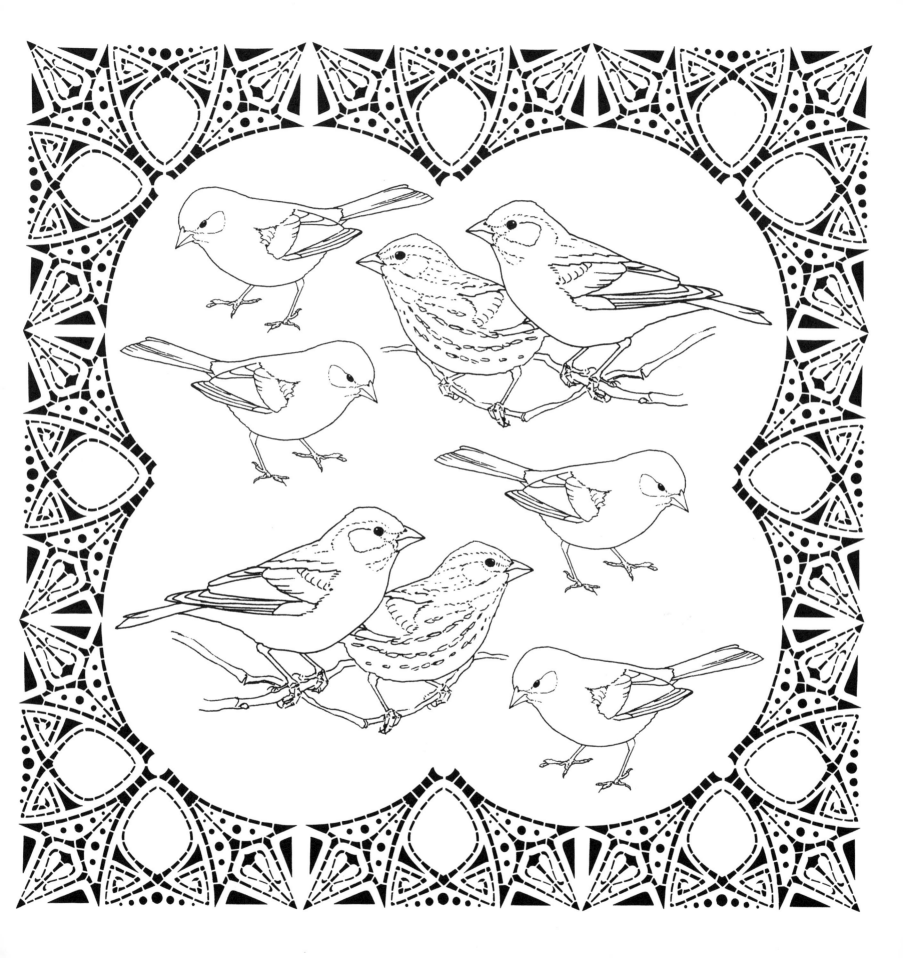

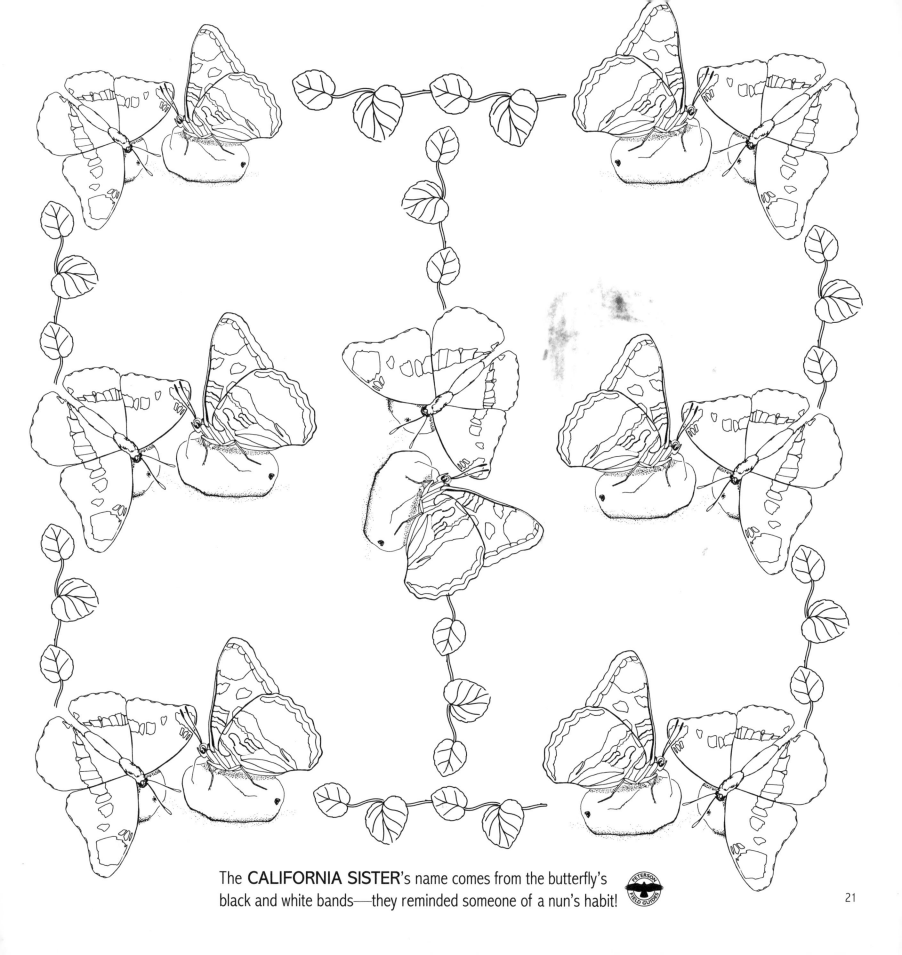

The **CALIFORNIA SISTER**'s name comes from the butterfly's black and white bands—they reminded someone of a nun's habit!

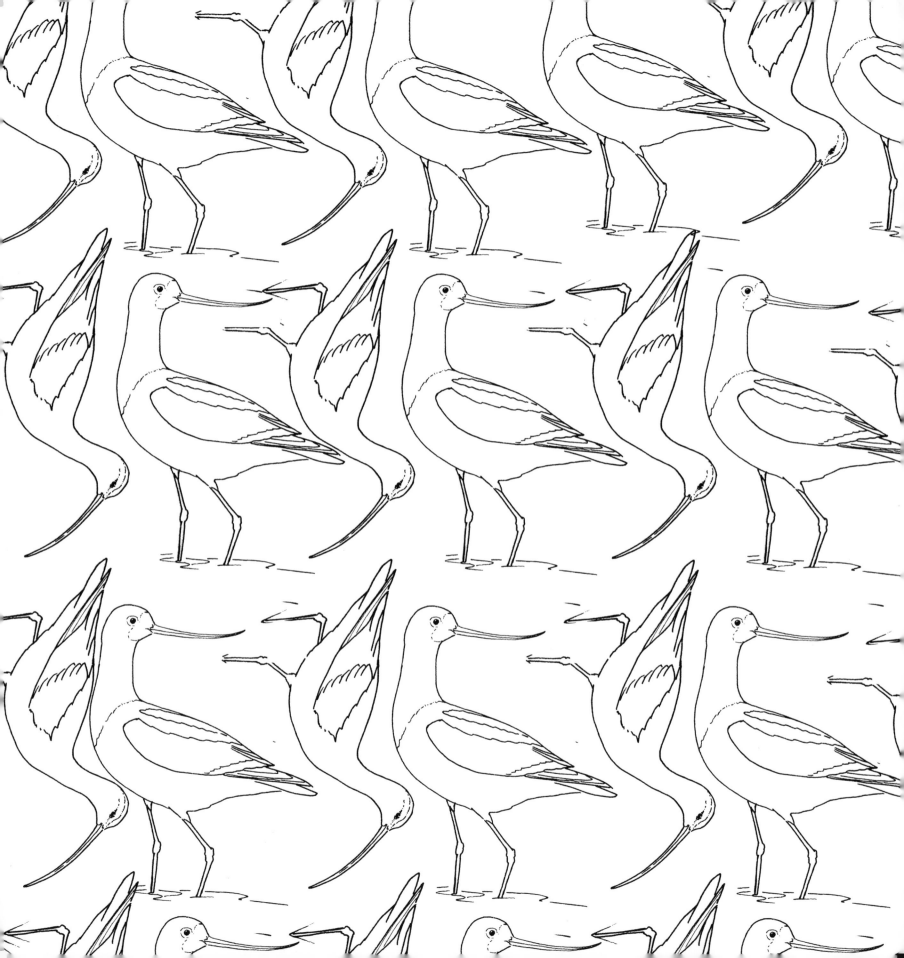

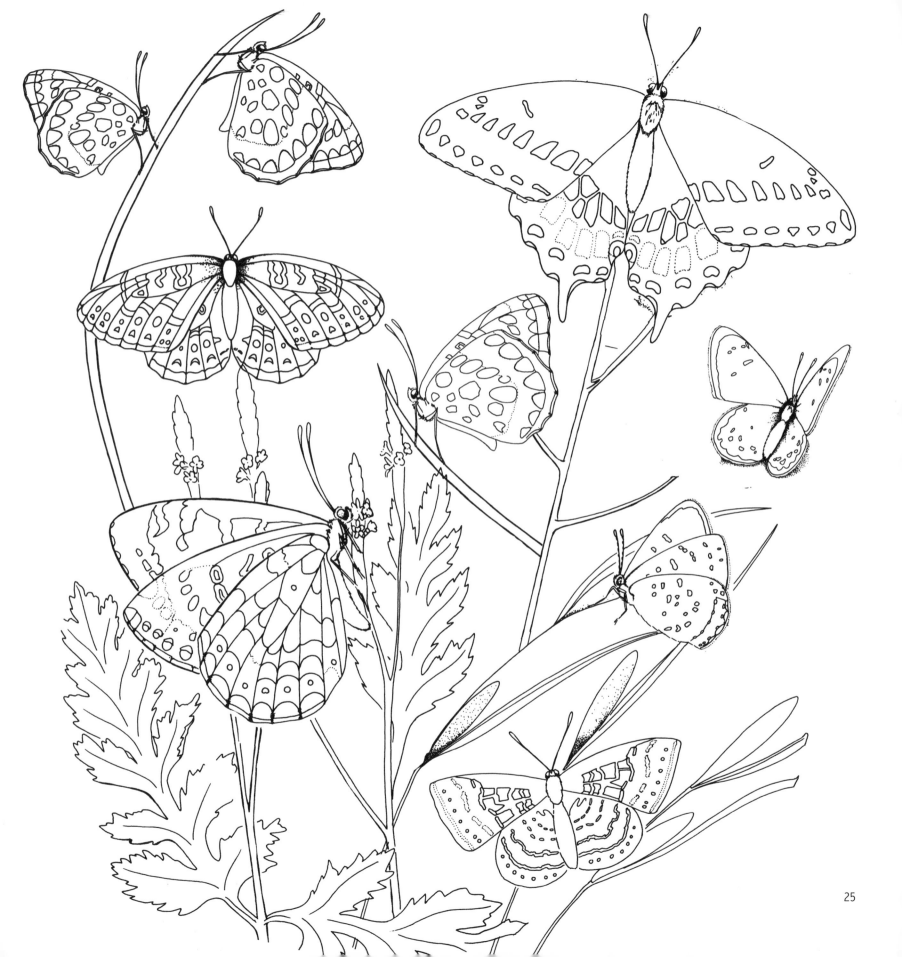

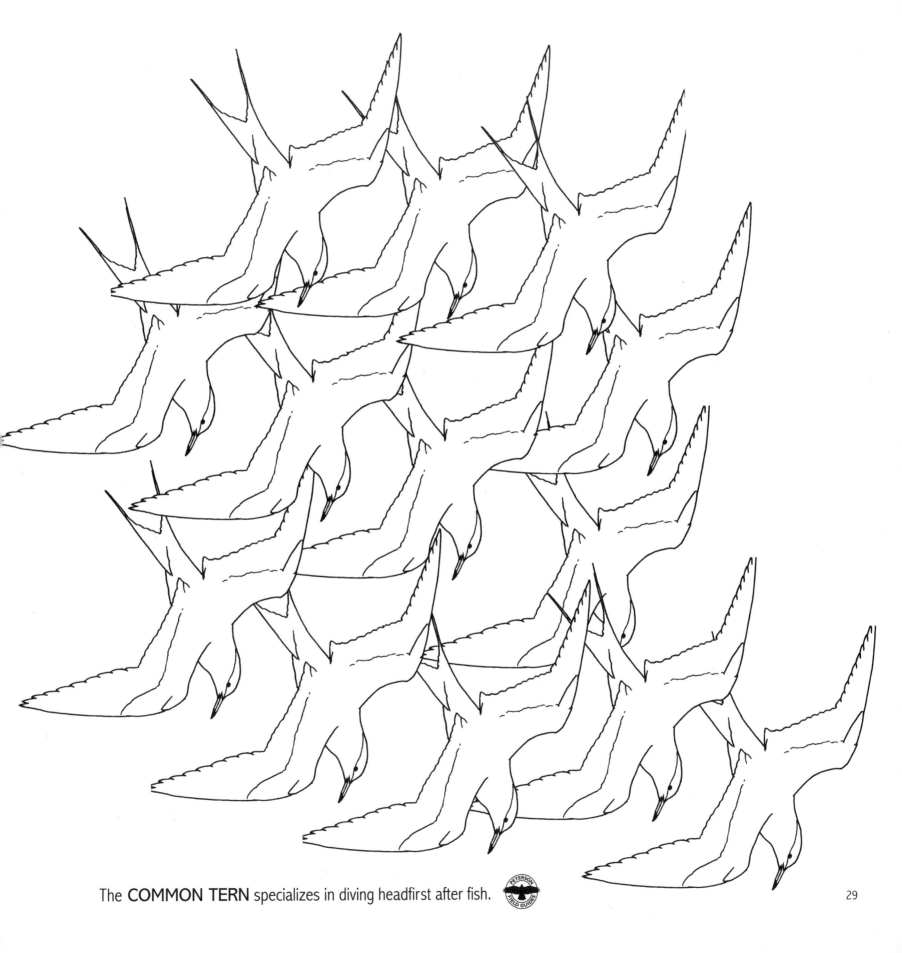

The **COMMON TERN** specializes in diving headfirst after fish.

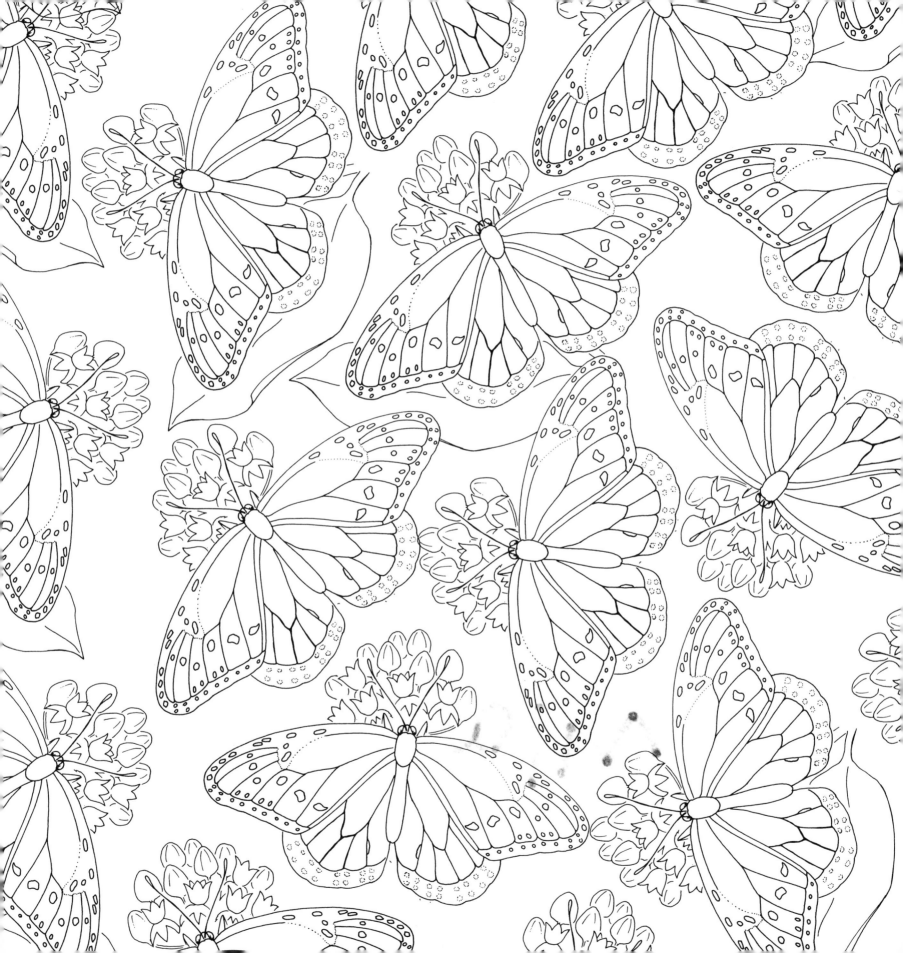

mia

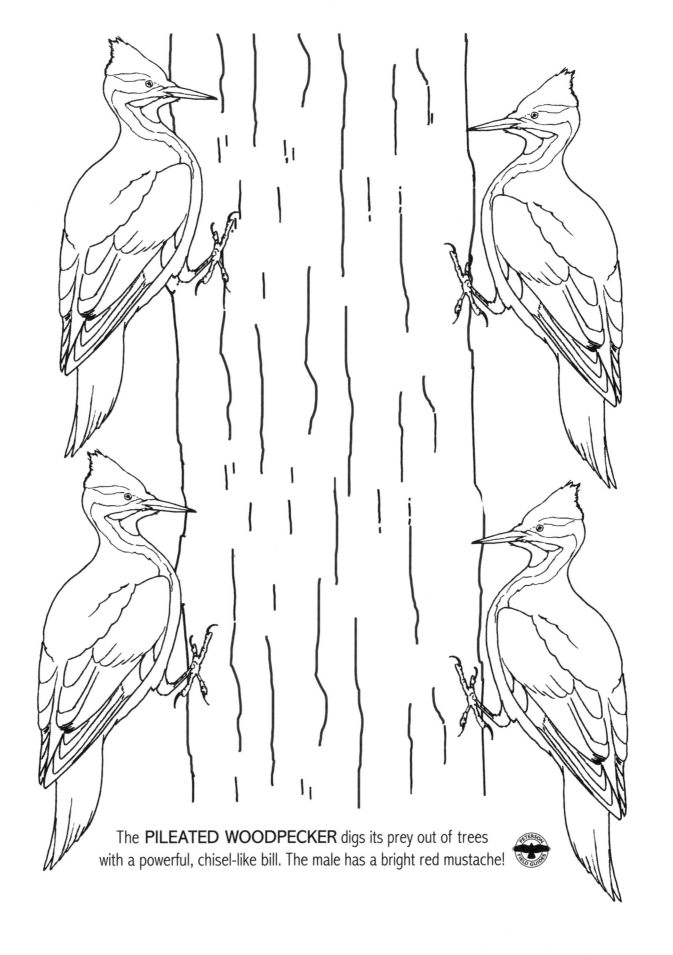

The **PILEATED WOODPECKER** digs its prey out of trees with a powerful, chisel-like bill. The male has a bright red mustache!

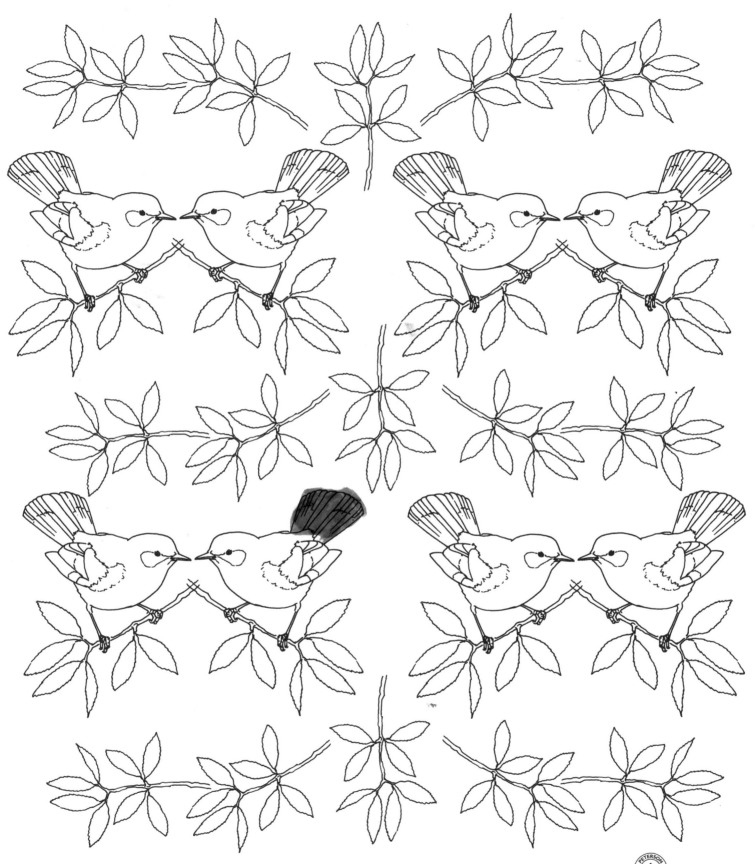

The **AMERICAN REDSTART** constantly fans its tail and flits out its wings like a butterfly!

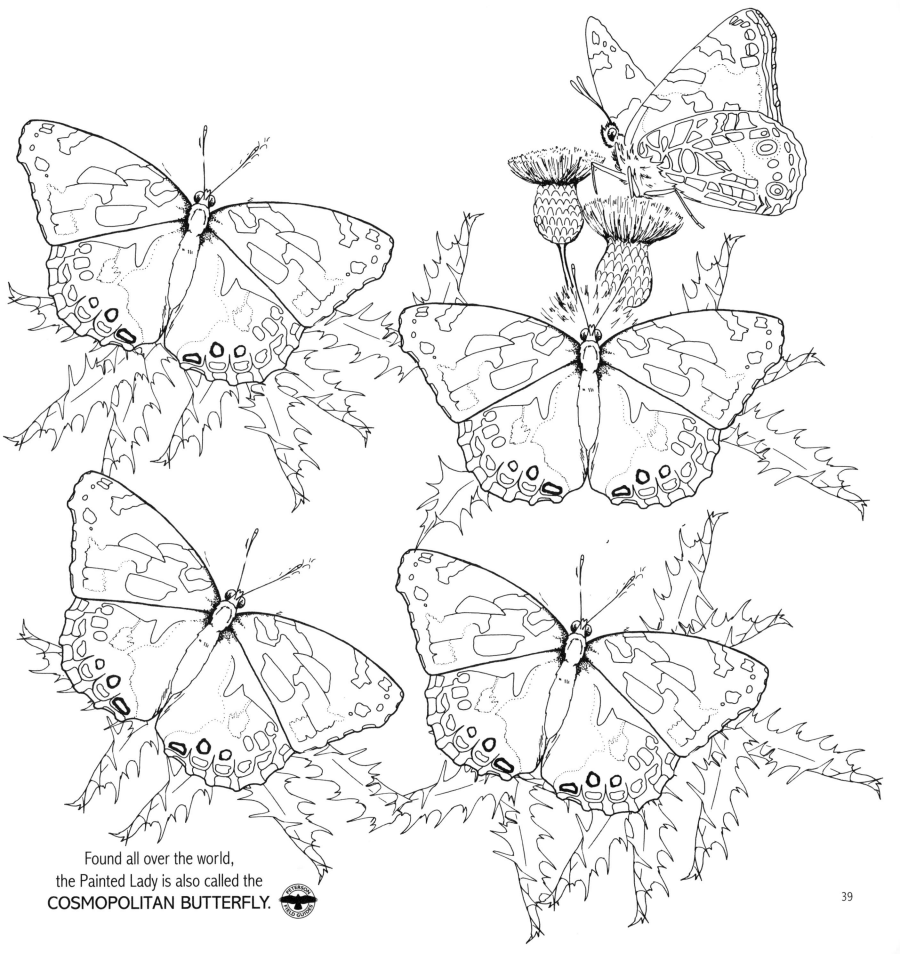

Found all over the world,
the Painted Lady is also called the
COSMOPOLITAN BUTTERFLY.

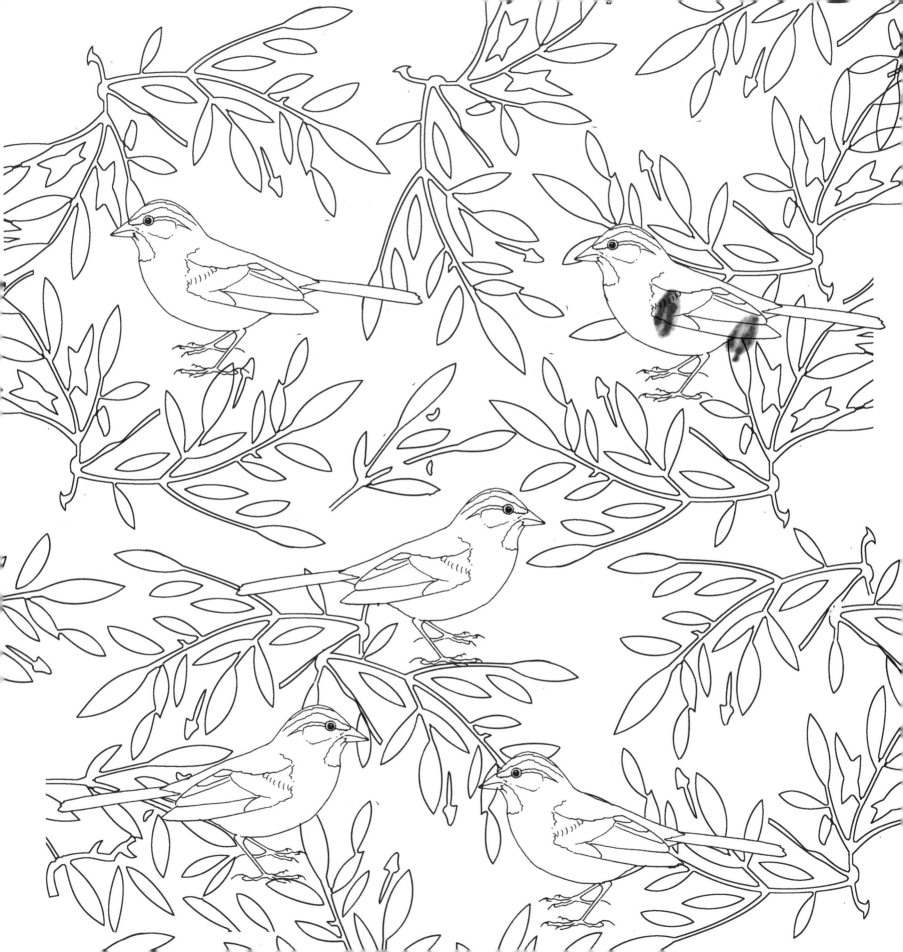

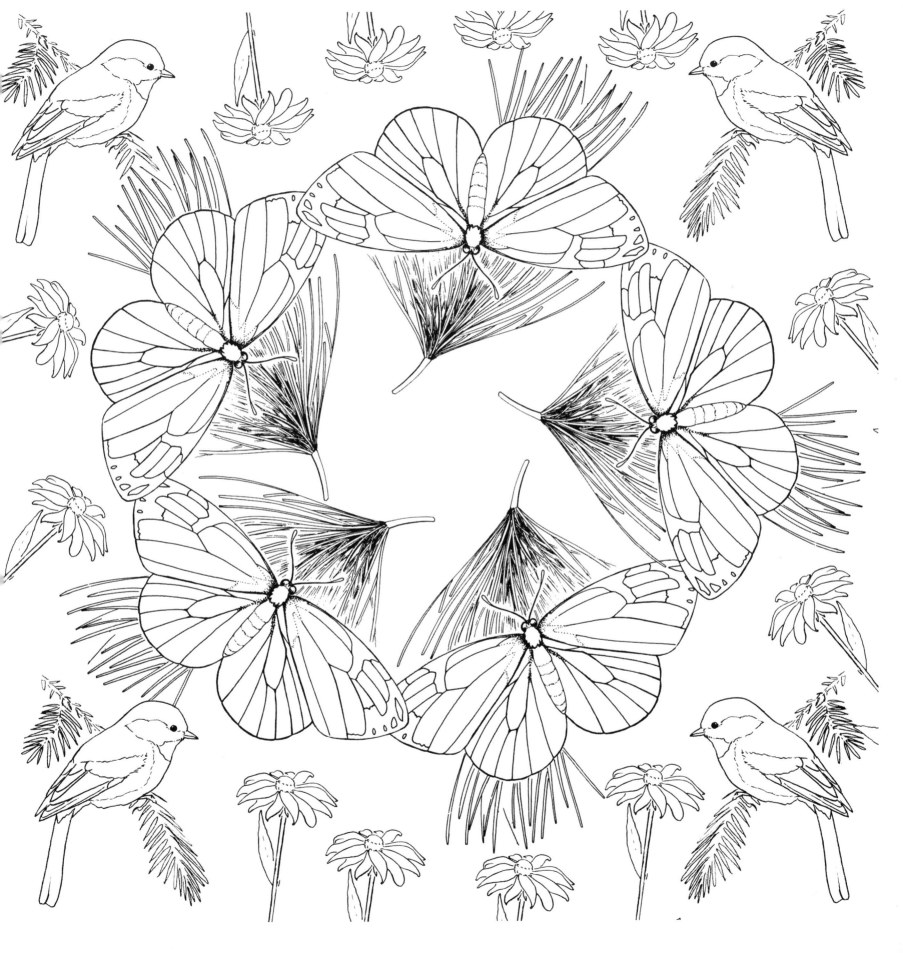

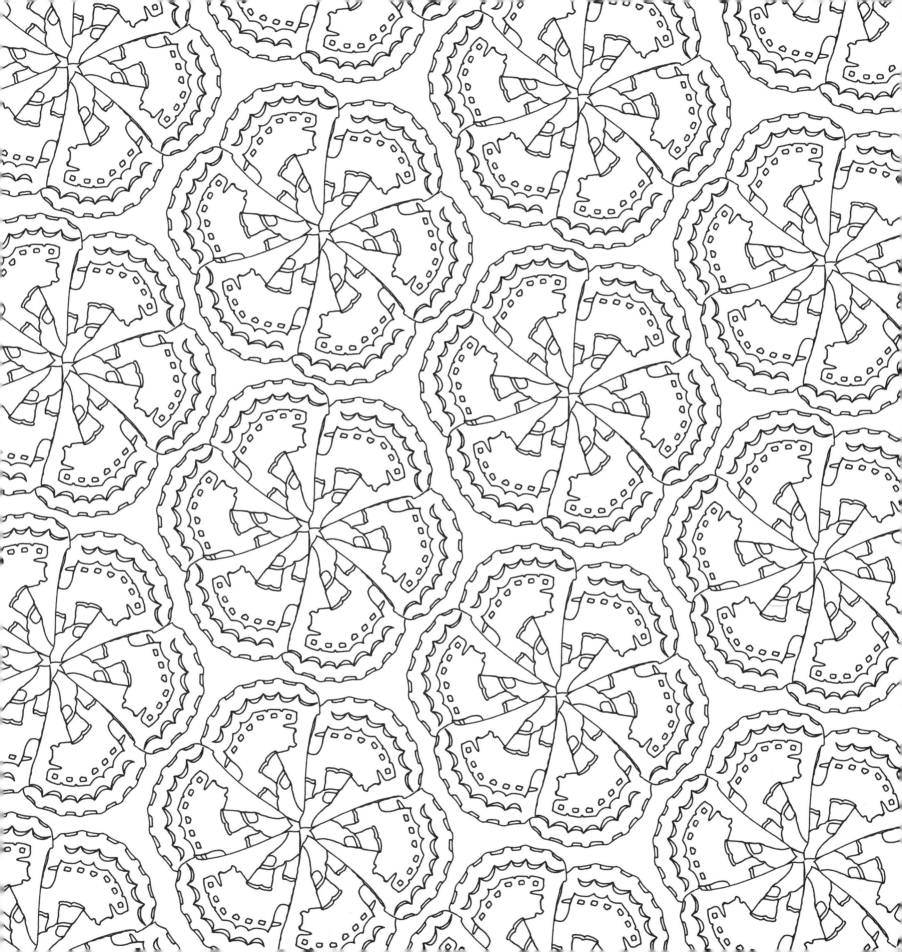

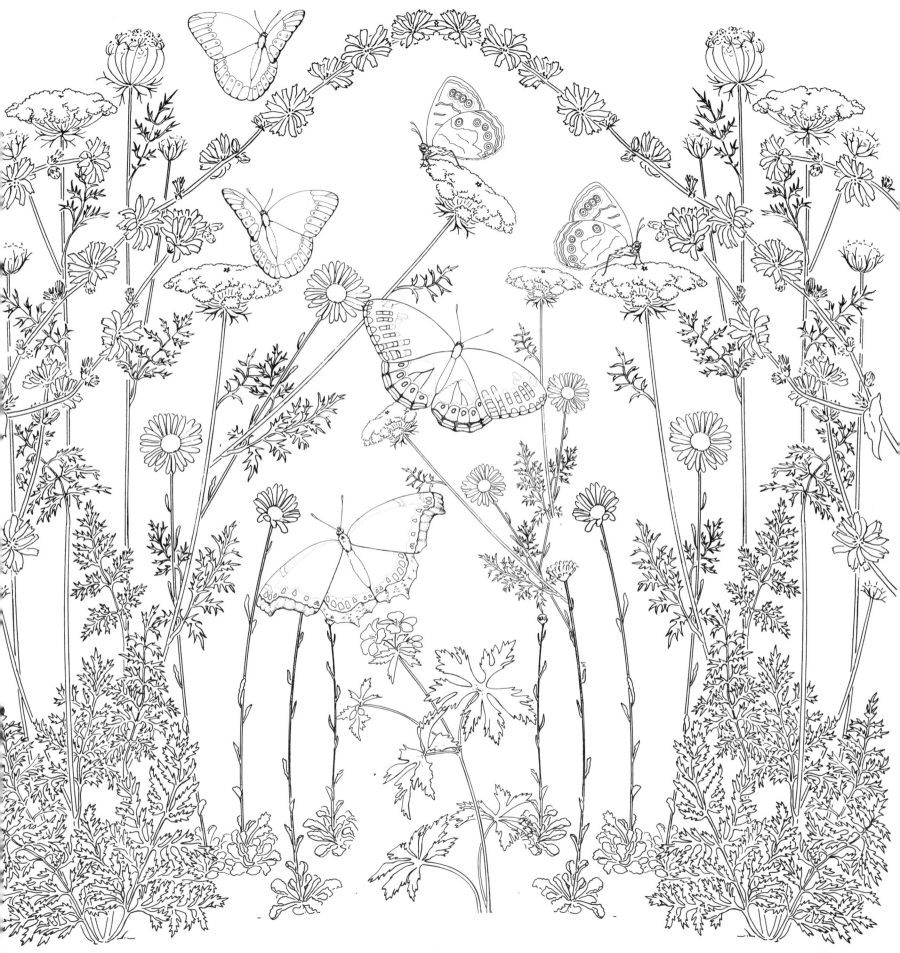

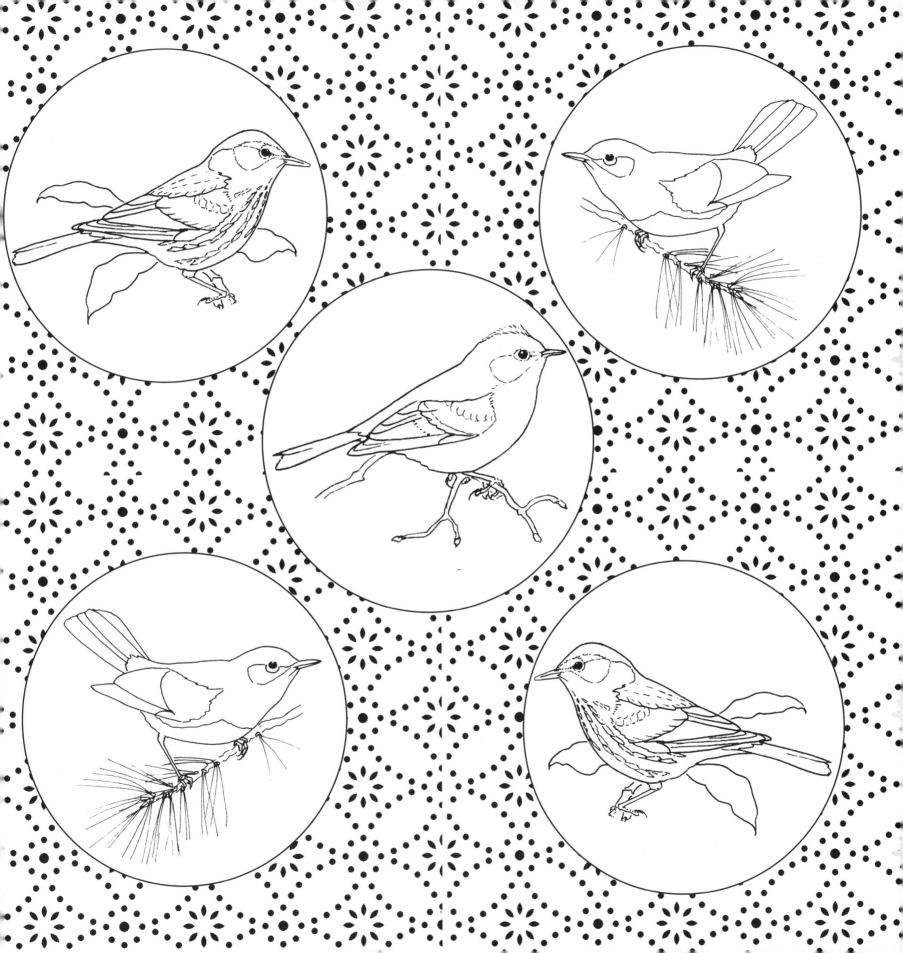

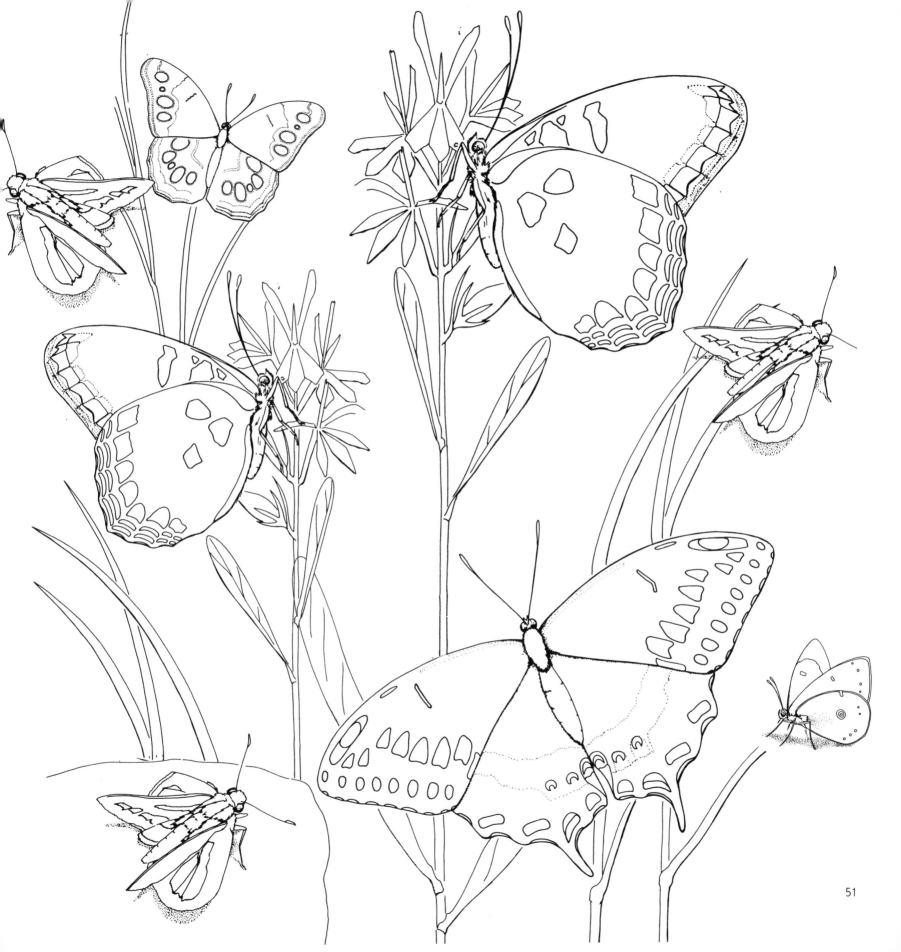

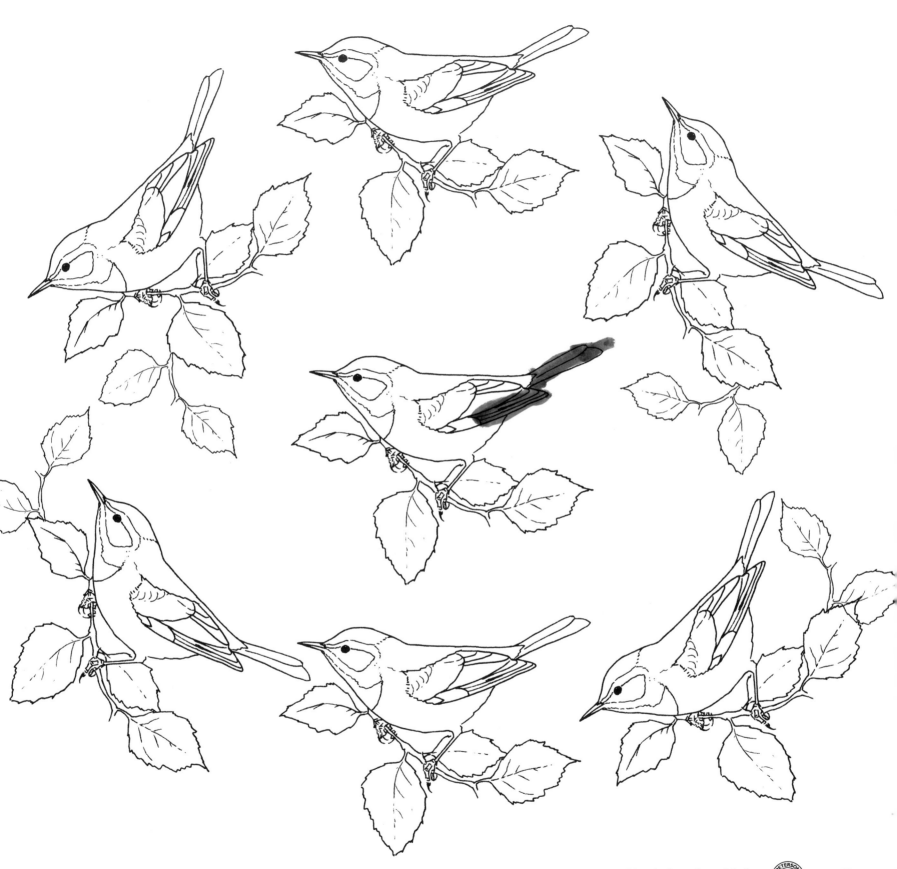

The **GOLDEN-WINGED WARBLER** is one of the most colorful and entertaining North American birds.

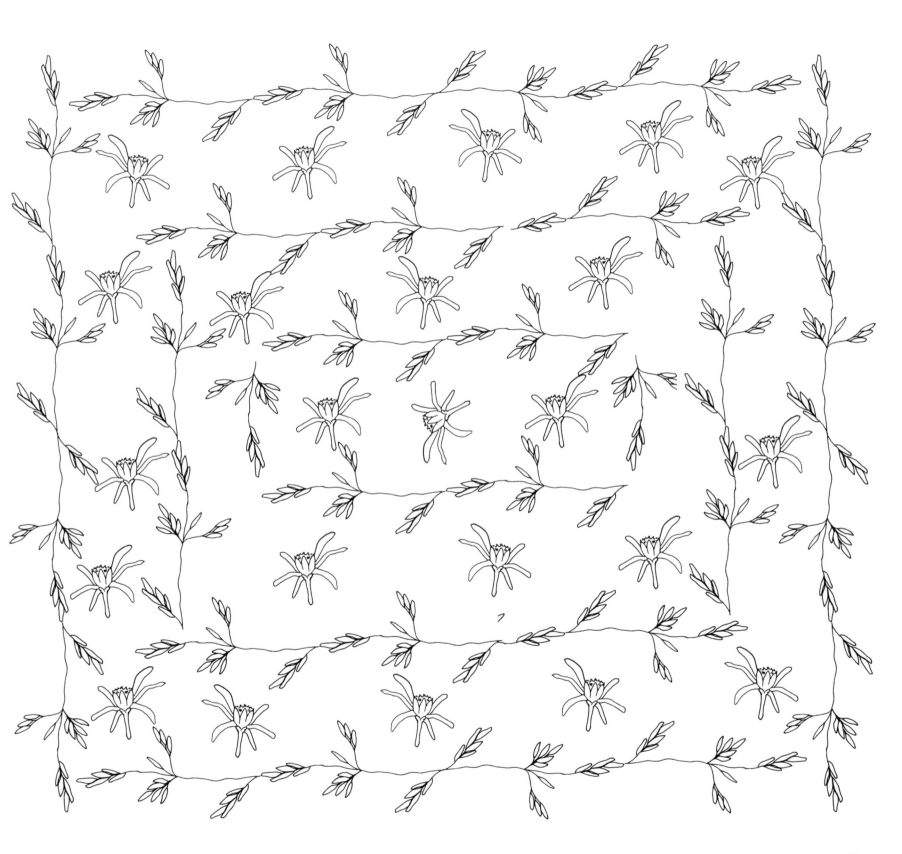

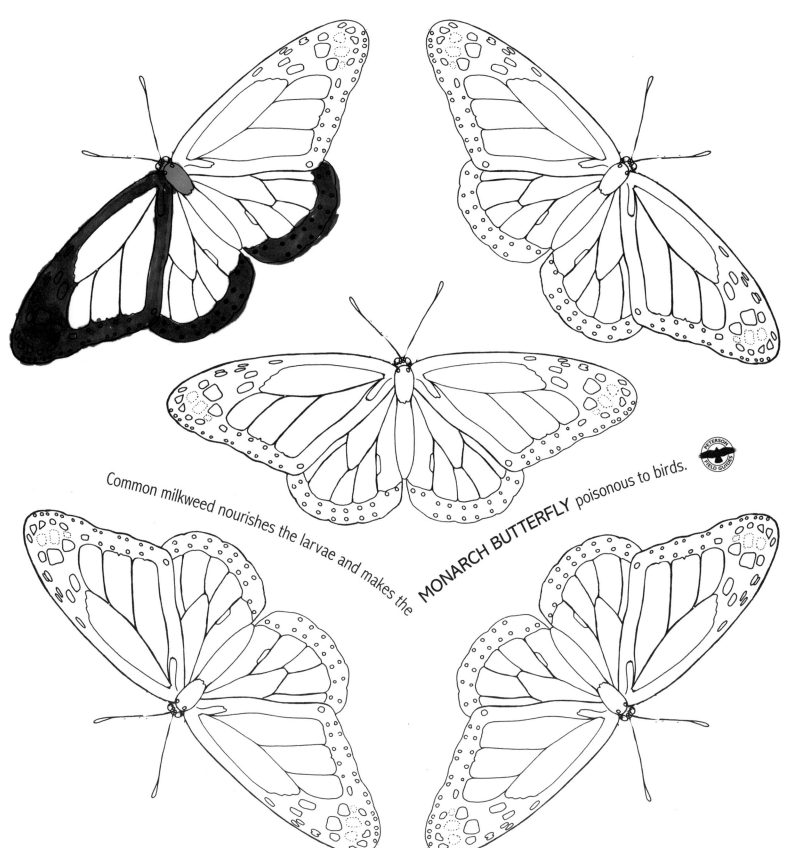

Common milkweed nourishes the larvae and makes the MONARCH BUTTERFLY poisonous to birds.

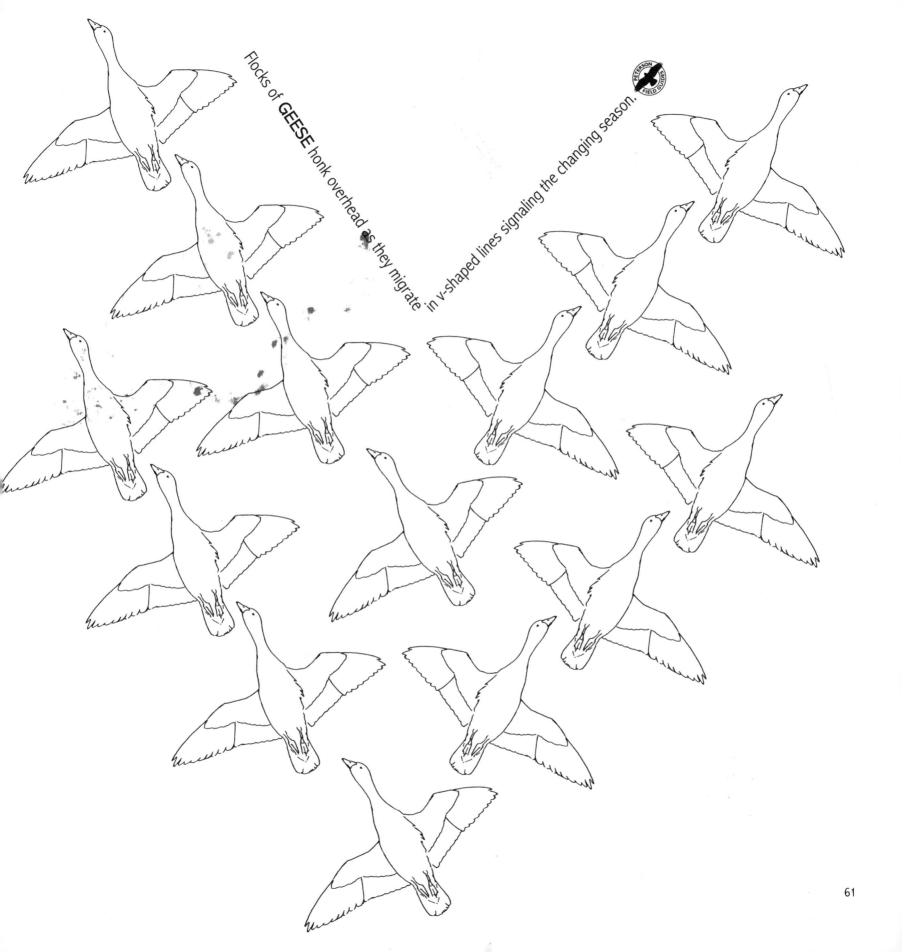

Flocks of **GEESE** honk overhead as they migrate in v-shaped lines signaling the changing season.

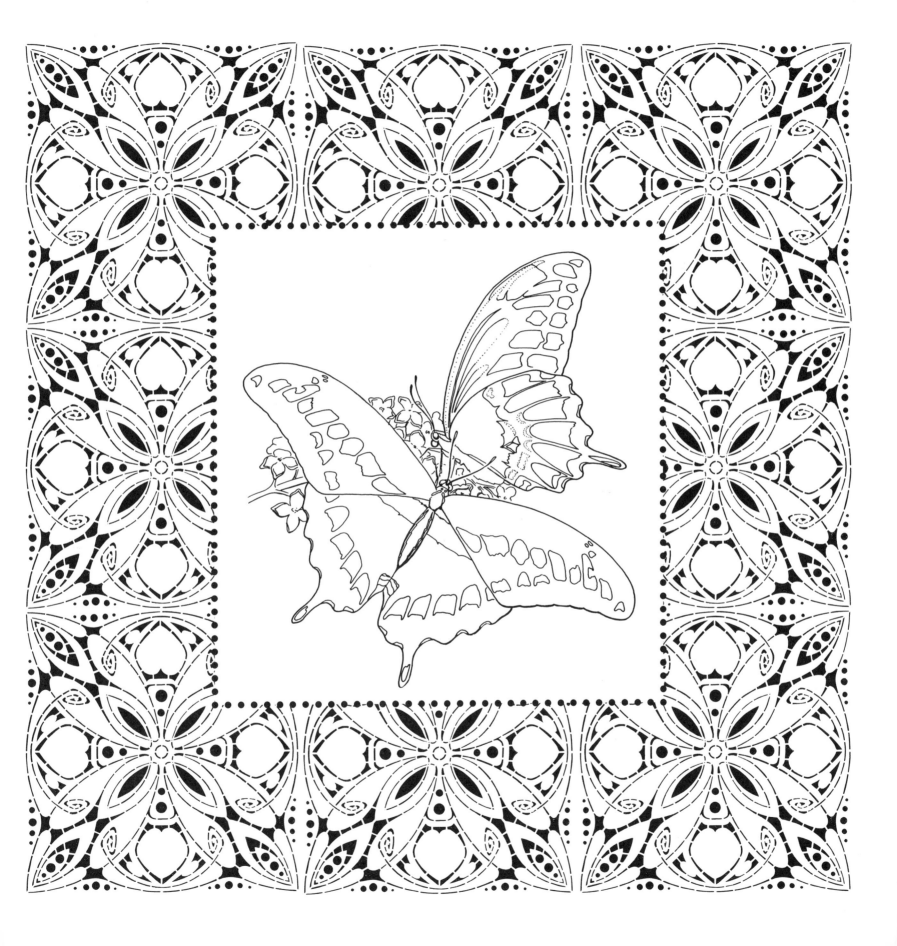

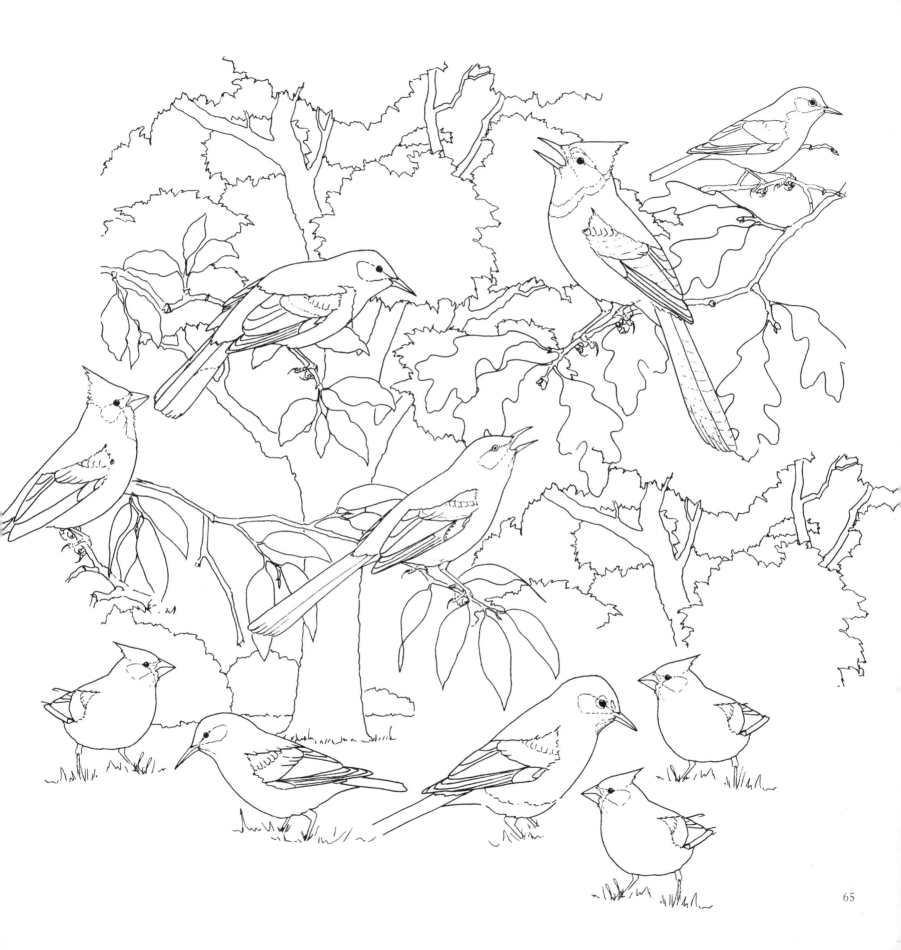

BUTTERFLIES
have four life stages.

The **DIANA FRITILLARY** is named for the Greek goddess of the woods.

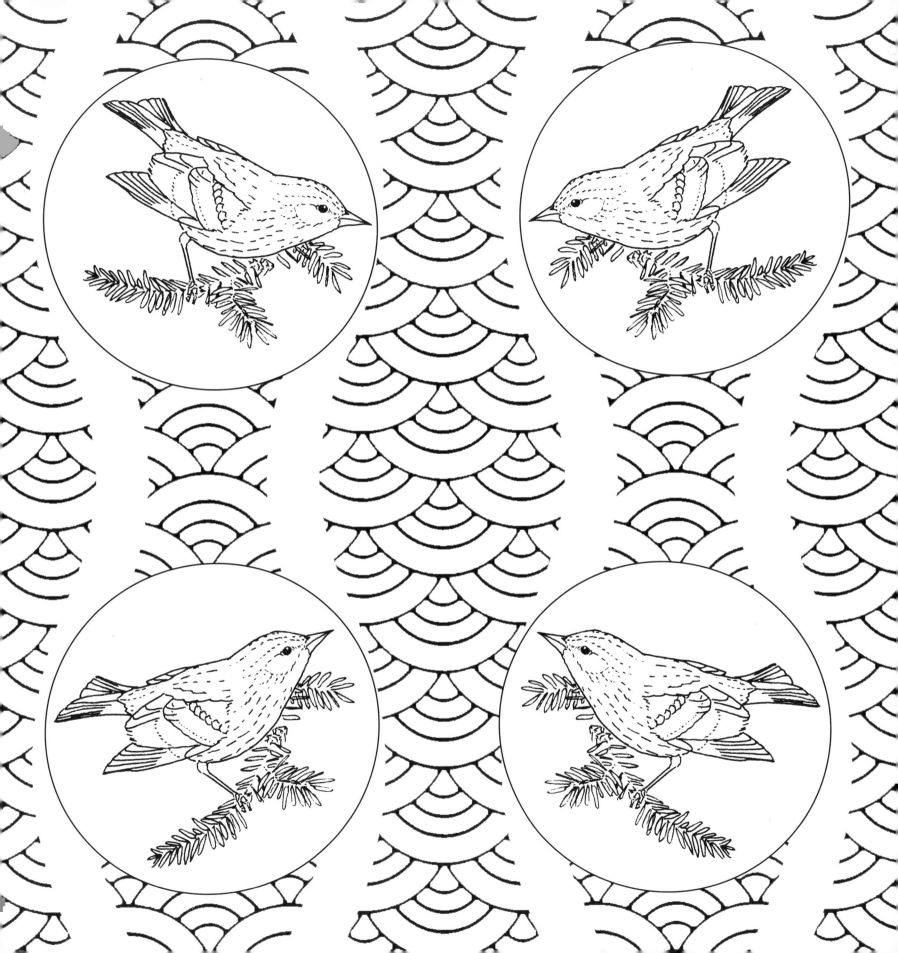

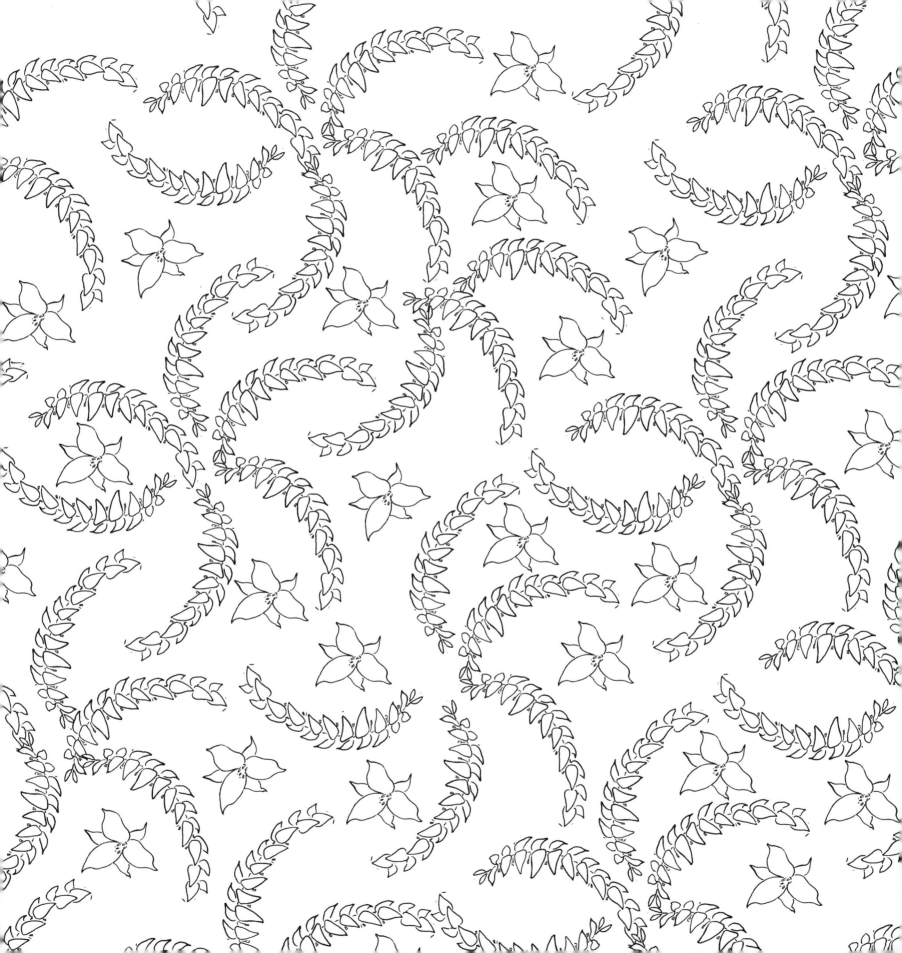

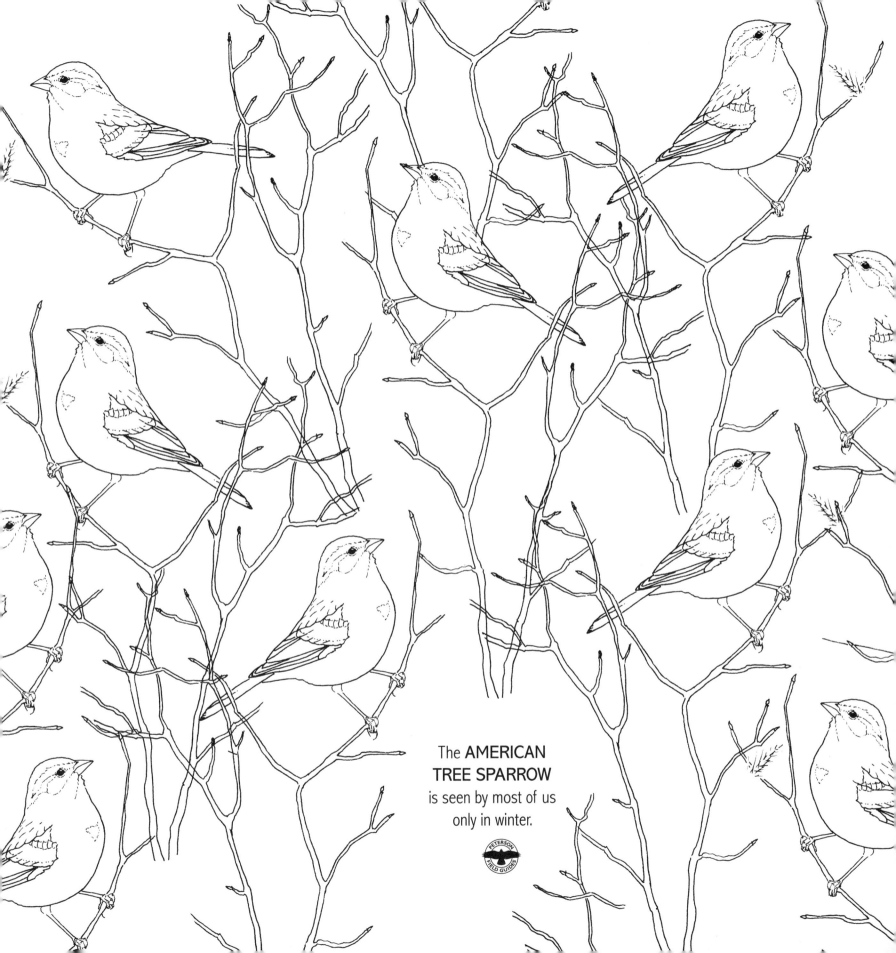

The **AMERICAN TREE SPARROW** is seen by most of us only in winter.

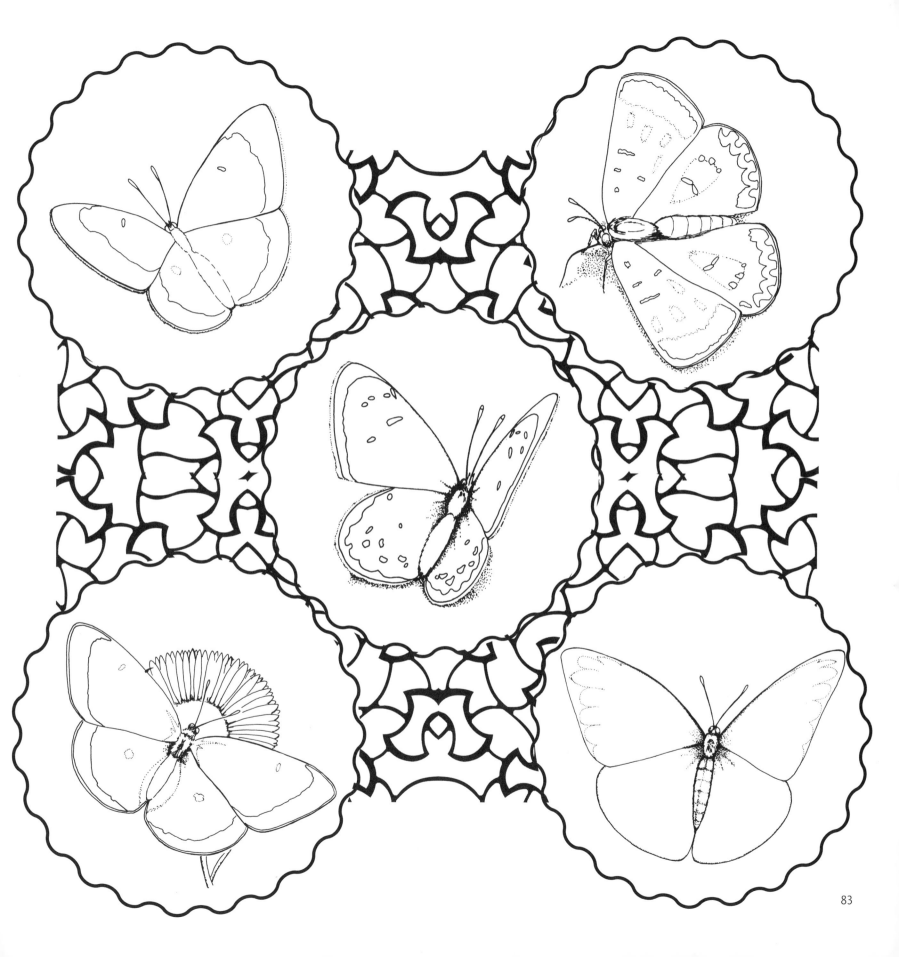

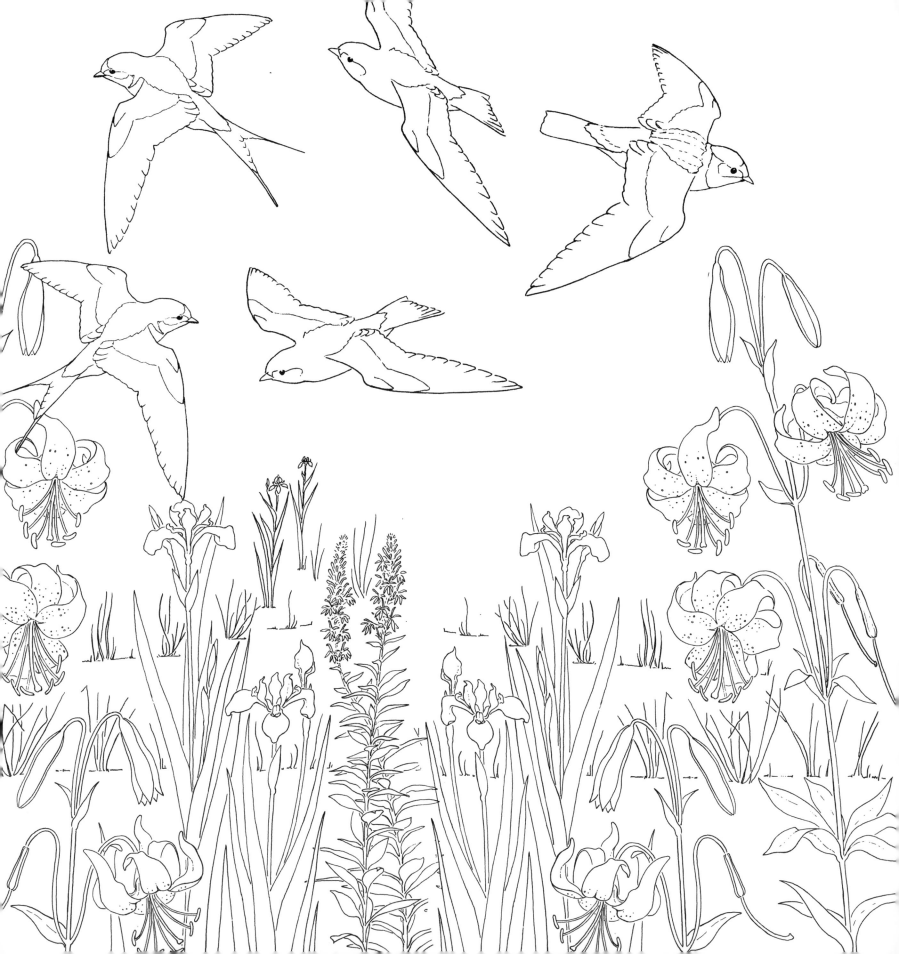

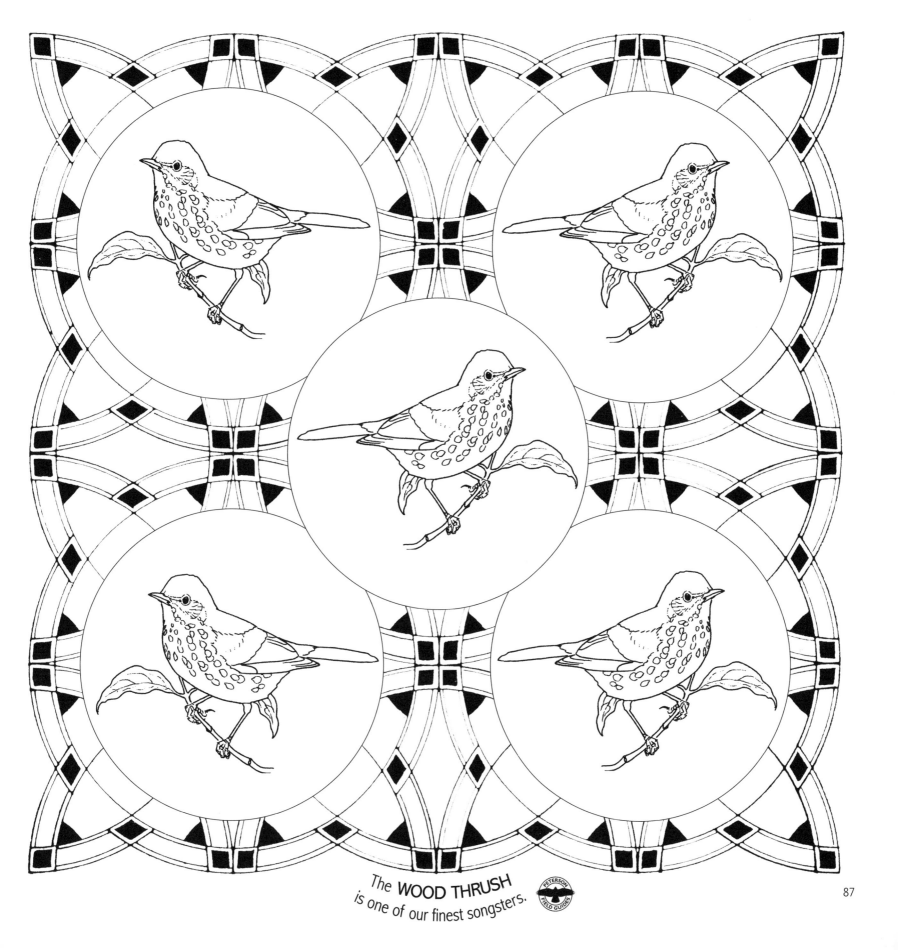

The **WOOD THRUSH**
is one of our finest songsters.

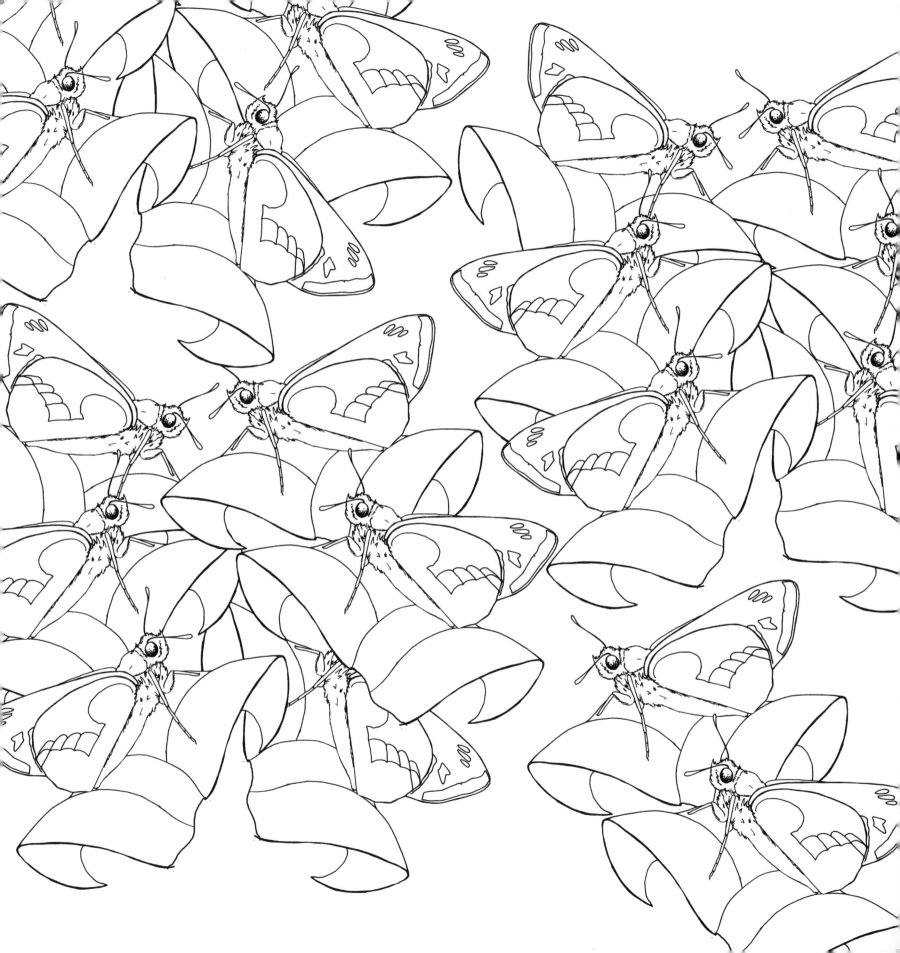

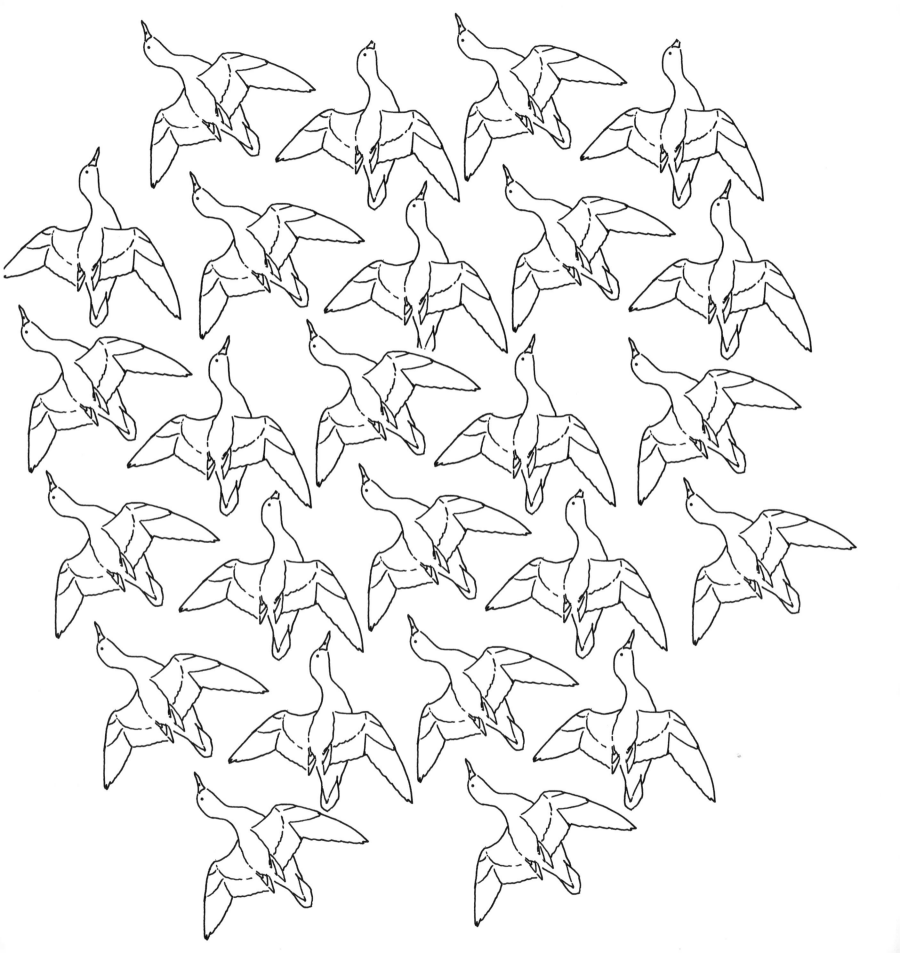

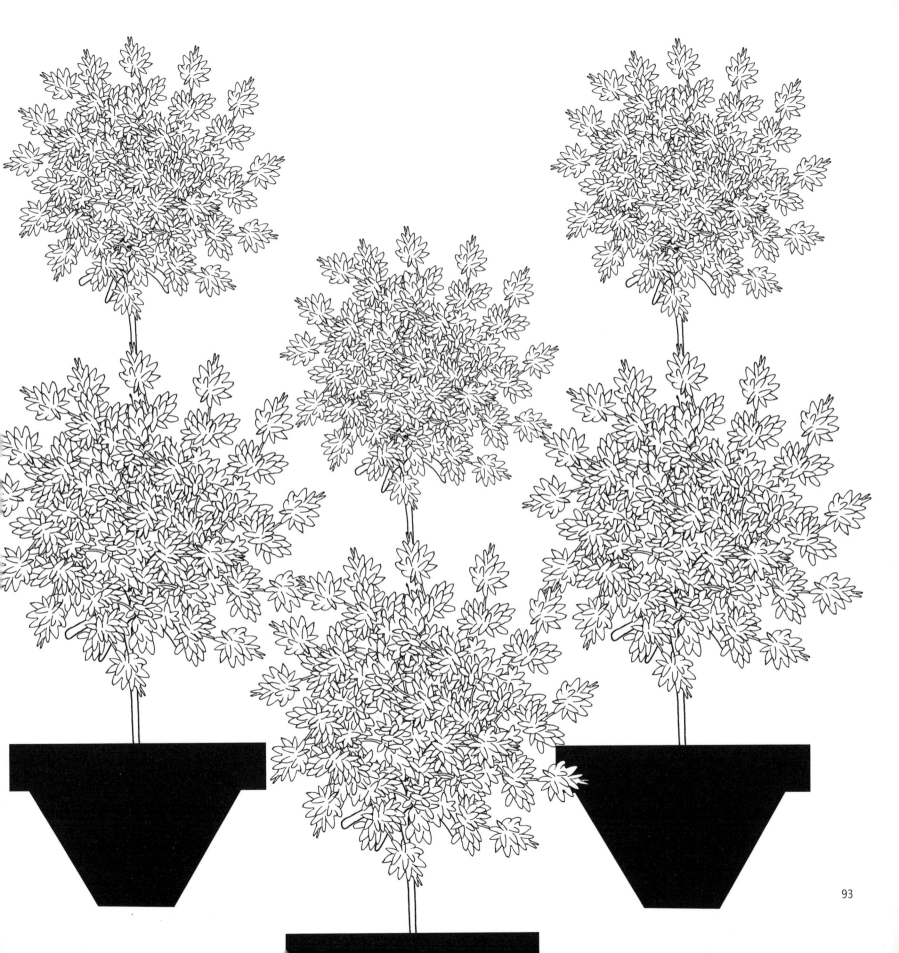